LA GRANGE PUBLIC LIBRARY

3 1320 00390 5234

W9-BPJ-380

WITHDRAWN

LA GRANGE
PUBLIC LIBRARY

10 West Cossitt Avenue
La Grange, IL 60525
lagrangelibrary.org 708.352.0576

DEMCO

LA GRANGE PUBLIC LIBRARY
10 WEST COSSITT
LA GRANGE, ILLINOIS 60525

Drawing **MOVIE MONSTERS** Step-by-Step

Drawing FRANKENSTEIN

Greg Roza

WINDMILL BOOKS
New York

J
743
MON

$27.00

Published in 2011 by Windmill Books, LLC
303 Park Avenue South, Suite # 1280, New York, NY 10010-3657

Copyright © 2011 by Windmill Books, LLC

All rights reserved. No part of this book may be reproduced in any form without permission in writing from the publisher, except by a reviewer.

CREDITS:
Edited by: Jennifer Way
Book Design: Julio Gil
Art by Planman, Ltd.

DEC 2011

Photo Credits: Cover, pp. 12, 20 John Kobal Foundation/Getty Images; pp. 4, 5 Shutterstock.com; pp. 6, 8, 10, 14, 16, 18 Everett Collection.

Library of Congress Cataloging-in-Publication Data

Roza, Greg.
 Drawing Frankenstein / by Greg Roza.
 p. cm. — (Drawing movie monsters step-by-step)
 Includes index.
 ISBN 978-1-61533-014-0 (library binding) — ISBN 978-1-61533-019-5 (pbk.) —
 ISBN 978-1-61533-020-1 (6-pack)
 1. Monsters in art. 2. Frankenstein's monster (Fictitious character) in art. 3. Drawing—
Technique. I. Title.
 NC825.M6R685 2011
 743'.87—dc22

 2010004900

Manufactured in the United States of America

For more great fiction and nonfiction, go to www.windmillbooks.com.

CPSIA Compliance Information: Batch #S10W: For further information contact Windmill Books, New York, New York at 1-866-478-0556.

Contents

It's Alive!

A lifeless body lies on a table. The **evil** scientist Dr. Frankenstein throws a switch. The dark lab fills with the buzz of his machines. "It's alive!" the mad doctor shouts as his monster rises from the table.

PENCIL

The story of Frankenstein's monster was written by Mary Shelley in 1818. She wrote *Frankenstein* to win a storytelling contest with her friends. Frankenstein later became one of the most memorable movie monsters of all time. Let's learn more about Frankenstein and how to draw him.

YOU WILL NEED THE FOLLOWING SUPPLIES:

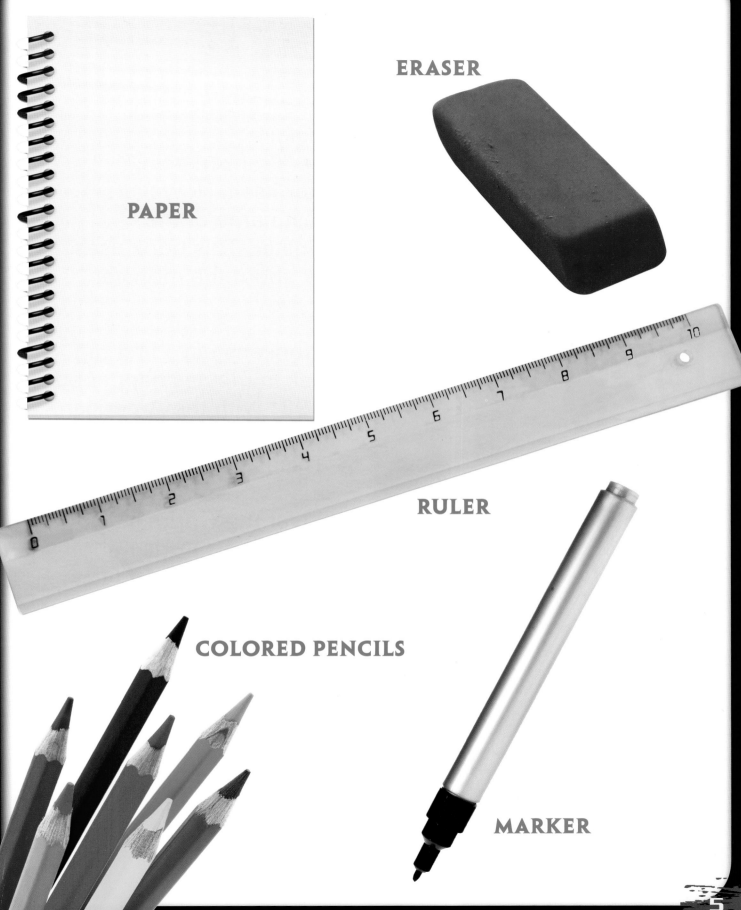

PAPER

ERASER

RULER

COLORED PENCILS

MARKER

Frankenstein's Big Break

When people use the name "Frankenstein," they usually mean the monster itself. However, Frankenstein is actually the last name of the scientist who created the monster. This book uses the name Frankenstein to talk about the monster.

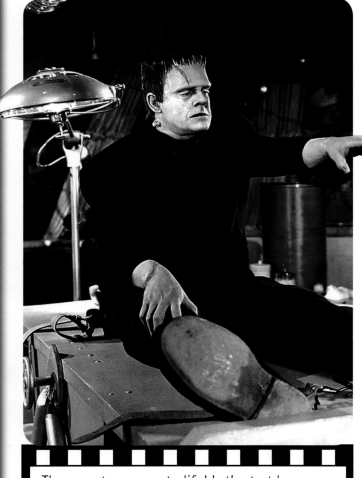

The monster comes to life! Let's start by drawing Frankenstein as he first gets up from the scientist's table.

Frankenstein's first big break in movies happened in 1931 with the American movie *Frankenstein*. This is the movie that made the monster a star all over the world. It also helped make Boris Karloff, the actor who played the monster, very famous.

STEP 1
Draw shapes as shown for the head and body.

STEP 2
Add ovals around the body outline.

STEP 3
Join the ovals with curved lines to form the arms, legs, hands, and feet.

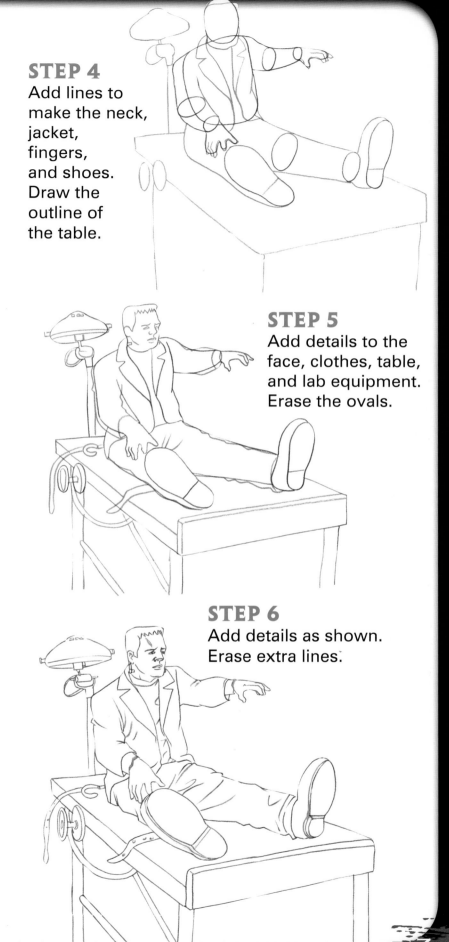

STEP 4
Add lines to make the neck, jacket, fingers, and shoes. Draw the outline of the table.

STEP 5
Add details to the face, clothes, table, and lab equipment. Erase the ovals.

STEP 6
Add details as shown. Erase extra lines.

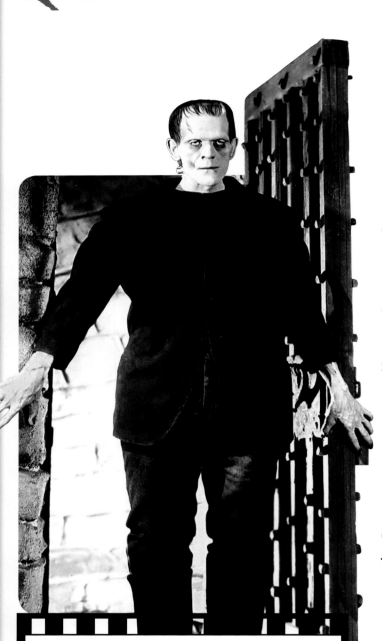

Here he comes! This is a color photo of the monster from the 1931 movie *Frankenstein*. Let's try drawing him.

The story in the 1931 movie *Frankenstein* is different from Mary Shelley's novel. In the novel, Dr. Frankenstein builds and brings to life a human being using materials in his lab. In the movie, Dr. Frankenstein creates his monster from body parts that have been stolen from graves.

In the novel, the monster is angry because he is treated badly by others. In the 1931 movie, the monster is angry because the doctor gave him a criminal's brain!

STEP 1

Draw the outline of the head and a rounded rectangle for the body.

STEP 2

Add small ovals as shown to guide you as you draw the arms and legs.

STEP 3

Join the ovals to form the arms, legs, hands, and feet.

STEP 4

Add Frankenstein's hairline, ears, jacket, fingers, and shoes. Draw the bolts on his neck.

STEP 5

Add the facial features. Add detail to the clothing. Erase the guides.

STEP 6

Add more details. Erase extra lines.

Creating a Monster

The Frankenstein that monster-movie fans know and love was first created for the 1931 movie, *Frankenstein*. Jack Pierce was the makeup artist who gave the monster his square forehead and green skin. Pierce also put two bolts on the monster's neck.

Maybe the monster just wants a hug. Let's not stick around to find out! Grab your pencils and try drawing a close-up of the monster's face.

Boris Karloff was the actor who made Frankenstein famous. He came up with the slow Frankenstein walk. Of course, each of Karloff's boots weighed 13 pounds (6 kg), so that helped him to perfect the monster's walk!

STEP 1
Draw the outline of the head.

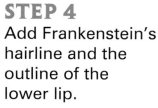

STEP 4
Add Frankenstein's hairline and the outline of the lower lip.

STEP 2
Add the outlines of the eyes and the mouth.

STEP 5
Draw the nostrils. Add the bolts on the neck. Add details to the neck, face, and forehead.

STEP 6
Draw scars and lines on the face. Add details to the facial features. Add shading and color.

STEP 3
Add the outlines of the eyebrows, ears, nose, and neck.

In 1935, *The Bride of Frankenstein* introduced fans to a female monster. Boris Karloff returned as Frankenstein, and Elsa Lanchester played his bride.

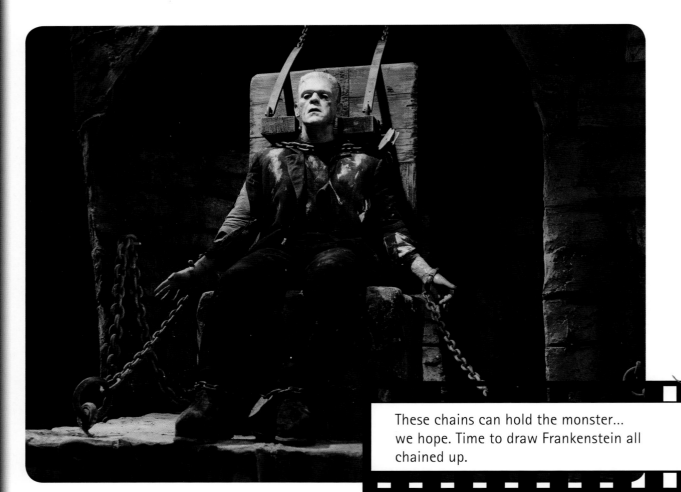

These chains can hold the monster... we hope. Time to draw Frankenstein all chained up.

In 1939, Karloff played the monster once again in *The Son of Frankenstein*. In this film Dr. Frankenstein's son Wolf tries to continue his father's work. He does this because he wants to restore his father's **reputation** as a scientist. Because this is a horror movie, Wolf's plan doesn't work out!

STEP 1

Draw the outline of the head. Add a shape for the body.

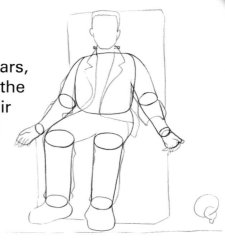

STEP 4

Add the hairline, ears, and fingers. Draw the outlines of the chair and clothes. Begin the rings that hold the chains.

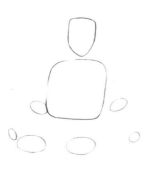

STEP 2

Add ovals to use as guides for drawing the arms and legs.

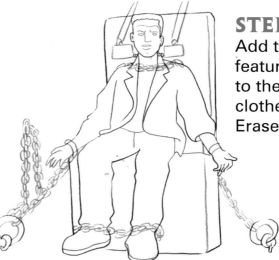

STEP 5

Add the facial features and details to the chains, clothes, and chair. Erase the guides.

STEP 3

Draw arms, legs, hands, and feet using the guides. Add lines for the neck and bolts.

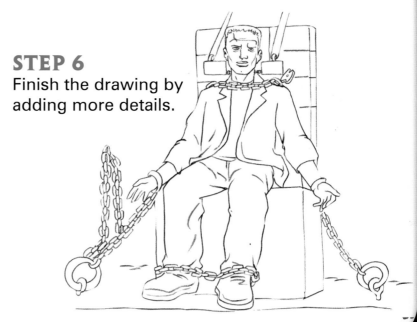

STEP 6

Finish the drawing by adding more details.

The Frankenstein movies were huge hits! They helped make Frankenstein one of the most popular movie monsters of all time. They also helped make other American movie monsters popular. These monsters included Dracula and the Mummy.

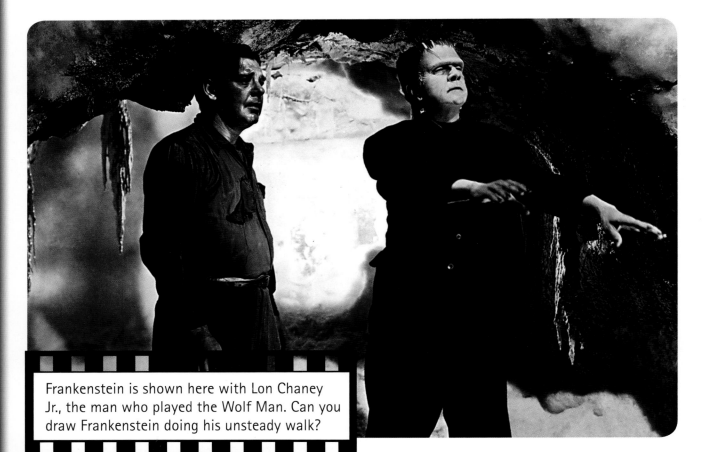

Frankenstein is shown here with Lon Chaney Jr., the man who played the Wolf Man. Can you draw Frankenstein doing his unsteady walk?

The monsters were so popular that they began appearing together in movies. Frankenstein battled the Wolf Man in the 1943 movie *Frankenstein Meets the Wolf Man*. Bela Lugosi played Frankenstein in this move. Lugosi first became famous for playing Dracula, however!

STEP 1

Draw the outlines of the head and body.

STEP 2

Add round guide shapes as shown.

STEP 3

Add lines to form the neck. Connect the guide shapes to draw the arms, hands, legs, and feet.

STEP 4

Draw the outline of Frankenstein's face. Draw the outline of the jacket.

STEP 5

Add details to the face and the clothes. Don't forget to add the bolts in Frankenstein's neck!

STEP 6

Add color to your drawing.

LA GRANGE PUBLIC LIBRARY
10 WEST COSSITT
LA GRANGE, ILLINOIS 6052

A New Frankenstein

After the wide success of the American monster movies, a British film company called Hammer Film Productions started a new series

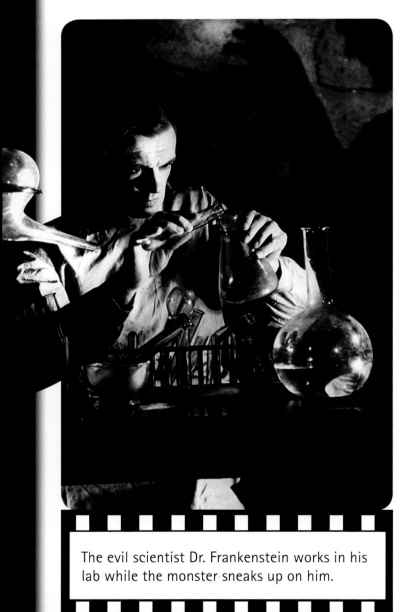

of monster movies. These films were much more violent and bloody than earlier Frankenstein movies. In the 1957 movie *The Curse of Frankenstein*, Peter Cushing played Dr. Frankenstein. Christopher Lee played the monster.

The Curse of Frankenstein marks the first time that Jack Pierce's original Frankenstein makeup was changed. Makeup artist Phil Leaky gave the British monster a new, scarier look.

The evil scientist Dr. Frankenstein works in his lab while the monster sneaks up on him.

STEP 1

Start by drawing a shape for the head and a shape for the body.

STEP 2

Add small, round shapes as shown.

STEP 3

Join the round shapes to create arms and hands. Add a line for the neck.

STEP 4

Draw the outlines of the face and hands. Add the outlines of the test tube and the beaker.

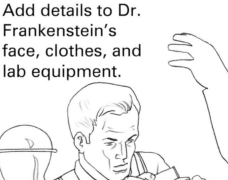

STEP 5

Add the face and hair. Add detail to the clothes. Add lab equipment. Draw the outline of the monster's shadow. Erase the guides.

STEP 6

Add details to Dr. Frankenstein's face, clothes, and lab equipment.

Since the first Frankenstein movie was made in 1910, more than 150 movies have been **inspired** by Mary Shelley's original novel! In 100 years, filmmakers have given fans many different **versions** of Frankenstein monsters to enjoy.

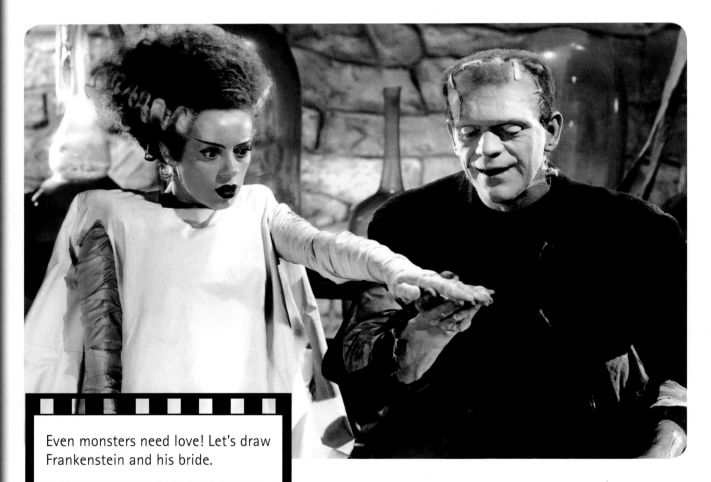

Even monsters need love! Let's draw Frankenstein and his bride.

Many Frankenstein movies are scary. Some, like the 1974 movie *Young Frankenstein*, are funny. In some movies the monster can talk. In others he just growls!

STEP 1
Draw the shapes that will guide you in drawing the happy couple.

STEP 2
Add round shapes around both bodies.

STEP 3
Draw lines for the necks. Use the round shapes to draw arms and hands.

STEP 4
Begin the faces and the clothes.

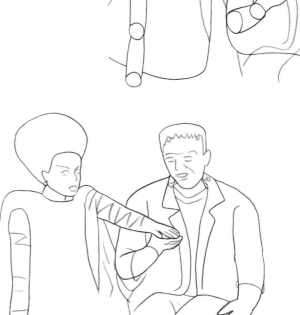

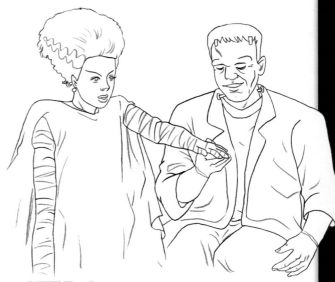

STEP 5
Draw the outlines of the facial features. Add lines to show the folds in their clothing. Erase the guide shapes.

STEP 6
Add details to the hair, clothes, and faces of both monsters.

Our Friend Frankenstein!

Frankenstein continues to be one of the most popular movie monsters of all time. Today, you can find his likeness in comics, cartoons, video games, toys, and even on cereal boxes!

Learning to draw Frankenstein can be fun, and it is a great way to practice your drawing skills. And who knows, you might inspire the next great Frankenstein movie!

Now that the monster is safely on the table again, let's give drawing Frankenstein one last try.

STEP 1

Draw the outline of the head. Add a larger shape with curved edges for the outline of the body.

STEP 2

Draw small circles and ovals around the body.

STEP 3

Draw the neck, arms, legs, hands, and feet using the circles and ovals.

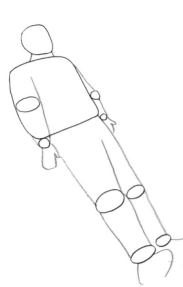

STEP 4

Draw the outline of the lab table. Add the hairline. Add lines for the jacket and for the straps holding Frankenstein to the table.

STEP 5

Add details to the lab table and to the straps. Add the eyes, eyebrows, nose, and lips.

STEP 6

Add details to the face and clothes. Now color your drawing. Good job!

Monster Fun Facts

- The first Frankenstein film was made in 1910. It is a silent film that is just 12 minutes long.

- During the filming of the 1931 movie *Frankenstein*, it took more than three hours to put on Boris Karloff's makeup every day.

- The 1960s television show *The Munsters* was a comedy about a family of monsters. The father, Herman, looked just like Frankenstein.

- The breakfast cereal Franken Berry showed a pink version of Frankenstein on the box.

Glossary

CURSE (KERS) A cause of unhappiness or harm.

EVIL (EE-vil) Bad.

INSPIRED (in-SPY-erd) To have moved someone to do something.

REPUTATION (reh-pyoo-TAY-shun) The ideas people have about another person, an animal, or an object.

RESTORE (rih-STOR) To put back, to return to an earlier state.

VERSIONS (VER-zhunz) Things that are different from something else, or having different forms.

VIOLENT (VY-lent) Strong, rough force.

Read More

Emberley, Ed. *Ed Emberley's Drawing Book of Halloween*. New York: Little, Brown, 2006.

Francis, Pauline. *Frankenstein*. London, UK: Evans Brothers, 2009.

Rex, Adam. *Frankenstein Makes a Sandwich*. Orlando, FL: Harcourt Inc., 2006.

Tallerico, Tony. *Monsters: A Step-by-Step Guide for the Aspiring Monster-Maker*. Mineola, NY: Dover Publications, 2010.

Index

Web Sites

For Web resources related to the subject of this book, go to: **www.windmillbooks.com/weblinks** and select this book's title.